Biblical Pictures Of Water

SEVEN SERMONS FOR LENT

STEVE SWANSON

C.S.S. Publishing Company, Inc.
Lima, Ohio

BIBLICAL PICTURES OF WATER

Copyright © 1986 by
The C.S.S. Publishing Company, Inc.
Lima, Ohio

6802 / ISBN 0-89536-784-X PRINTED IN U.S.A.

Table of Contents

1

Life From Water: The Ark

Genesis 6:11-22

Water is the very stuff of life. When God created the heavens and the earth, he put water right at the very heart of his system. More than seventy percent of our amazing world is covered with water and that water is teeming with life. It's true that beef, pork, and poultry are important to our diets as well as to our economy, but whenever some farmer gets a"big" head and begins to think that these are the only sources of non-vegetable protein, he or she should be reminded that ninety percent of this planet's creatures live in water.

The sea is our mother. Perhaps to remind us of that, God has arranged that all of us spend the first nine months of our lives swimming. Leaving that cozy bath is a shock, a trauma, which Dr. LeBoyer of France, and others since, have successfully lessened by putting newborn babies right back into lukewarm water once they are delivered.

Water, more than any other single substance, makes this planet inhabitable. Before there was even time, the Spirit of God moved over the face of the waters. (Genesis 1:2) Other than God himself, nothing on earth is older than water. God formed this earth, and is still shaping it, by using water. He washed down its mountains and filled up its valleys, planted the fields, forests, and gardens and nourished them with rain. With the sea and the land formed, God made creatures for the sea and air and land. Then he made man.

Water was extremely important in God's plan. It still is. Water has always been this world's thermostat. We use water in radiators and solar panels because water can contain heat and release it slowly. Without water our days would be deathly hot and our nights deathly cold — something like the weather on a desert. This world could not exist without water, and neither could we.

Water has some other interesting qualities. Like other liquids, when it gets cold, water gets denser. That's why cold water stays on the bottom of your hot water heater, and that's why, when you dive into a lake, you start out in warm water and go down into colder and colder water.

When water is cooled almost to freezing, an amazing, unpredictable, and terribly important thing happens. Instead of becoming more dense, suddenly it begins to become *less* dense. It rises to the surface and that's where it freezes.

Can you imagine the consequences if ice were heavier than water? "Great," you say, "then when I wanted to drink a lemonade, my moustache wouldn't always be getting stuck in the ice cubes."

Maybe so, but about the time you were ready for your second lemonade, the lakes would already have begun to freeze *from the bottom up*. Heat would never reach the ice to melt it. Marine life would soon die. More and more water would be trapped in ice. The rains would stop. There would be only two temperatures everywhere on this earth: very hot and very cold. Then we all would die.

Water also has more surface tension than any other liquid except mercury. "So what," you say. That's what lets spiders walk on water and what makes rain fall in drops. It's also what makes your blood and mine work — blood which is ninety percent water, blood which navigates all those miles of capillaries and keeps our muscles fed and our skin warm.

Surface tension and capillary action also allow water to move through membranes and glands in our bodies — and climb up through dirt and even sand to evaporate and feed the clouds, to water the roots of plants, and then to flow up through the thinnest tubes in the stalks of plants and the trunks of trees to feed the leaves and the seeds — the parts we eat, and that the animals eat; the parts that reseed and grow new plants year after year.

Water does many thrilling and exciting things for us; it is so amazing, so useful, so wonderful, no wonder we say "Ah" and smack our lips when we down a tall glass of water. We love water.

But we also fear water. Water scares the dickens out of most of us. Aquaphobia is among the most common of fears: the fear of water, the fear of drowning. That's what the great flood story, the story of Noah's ark, is all about. Of all stories, it's one to put the fear of God into people.

We have the story of Noah in our Bible because the larger story

of humankind, the story begun with Adam, had already turned sour:

> *The Lord saw that the wickedness of man was great in the earth*
> *. . .(Genesis 6:5)*

"The Lord was sorry that he had made man on the earth," it says. "I have determined to make an end of all flesh," said God. Man had become too sinful and God had repented of his decision to create man in the first place. Man was guilty of gross and miserable sins and God finally judged him unfit to inhabit the earth. The verdict was death — death by drowning; death by water.

The truth which emerges from this and the stories of all God's judgments upon humankind is that God always saves a remnant. In the flood story Noah and his family are that remnant. Everyone they knew, everyone around them, was doomed to die by water. Noah and his family received life by water. They lived because God had warned them and, because they were warned, they were prepared.

"Forewarned is forearmed," some wise sage once said. Jesus put it another way in one of his mini-parables:

> *If the householder had known in what part of the night the thief*
> *was coming he would have watched, and would not have let his house*
> *be broken into. (Matthew 24:43)*

"Forewarned is forearmed."

Maybe this is one of the messages that the story of Noah whispers to us from those dim and wispy ancient times. Maybe, as those ancient grandfathers taught the story of Noah to their grandchildren, they were reminding each generation that times of judgment are always on the horizon, that almost every generation must face some catastrophe or another because of human sin and weakness and cussedness.

"But," you say, "in the story of Noah, God promises never to destroy the world again." It's true. God says to Noah:

> *"I establish my covenant with you, that never again shall there be*
> *a flood to destroy the earth . . . I set my rainbow in the cloud, and*
> *it shall be a sign of the covenant between me and the earth." (Gen-*
> *esis 9:11, 13)*

There will, of course, always be natural disasters earthquakes, cyclones, hurricanes, tornadoes, prairie and forest fires — as well as floods. God doesn't need to bring gigantic disasters on the world any more. People nowadays have gotten so clever that they bring disaster after disaster upon *themselves* — and upon each other.

Who needs a flood or a famine or a plague when our world can produce a Hitler? Hitler's mad genocide, his murder of seven million European Jews, makes Noah's flood look like an April shower. There probably weren't anywhere near seven million people drowned at the time of Noah's flood.

One European madman today can do more damage than a flood. One invention of modern times — the automobile — has caused over two million deaths. Add to that the guns, bombs, radiation, spills, leaks, poisons, explosions, collapses, and all the other foolish and insane things we do to each other, to ourselves, and to our world, and you know the wickedness of humanity is still great in the earth and we all, sooner or later, must suffer for it.

What we long for in these evil days is the comfort and safety of an ark. Wouldn't it be nice if someone had built a nice cozy shell to wrap around us? Imagine how safe and comfortable it would feel to be inside looking out at a drowning world. Imagine living in our world today but being insulated from troubles in the Near East and Far East, and from the problems between world powers. Imagine not having to worry about controversies over economics or politics or wars and rumors of wars. Imagine being insulated from all that.

Our imaginations could go even farther. When Noah got into that ark, he got in with a bunch of animals and with his own family. The animals certainly didn't require much — an armful of hay now and then maybe — but other than the animals, there was just his own family. Imagine that. No neighbors, no outside influence, no pressure from job or society or school. Nobody flirting with husbands or wives or sweethearts. No locking things up for fear of thieves or rapists or murderers or madmen. No hiding anything or anyone. Very little hassle and very little trouble — except from his own family and, of course, from himself.

Noah's troubles came mostly *before* the flood. He certainly had to face plenty of ridicule and scorn when he was building that great ship on dry land, on dry days, and amidst the dry humor of the heckling neighborhood wags.

By faith Noah, being warned by God of events as yet unseen, took heed and constructed an ark for the saving of his household. (Hebrews 11:7)

He *did* save his household; he *did* have the last laugh. Somehow, though, the temptation to gloat over his good fortune, to stand on the deck of his ship and say, "I told you so," to rejoice in his own blessing as he heard the pleading, clamoring screams of those same jokers when they were up to their necks in water, somehow I can't picture Noah doing that.

It may be cozy and comfortable to be safe inside a watertight ship during a flood, but it's no fun to watch the rest of the world drowning.

That is much the same dilemma which has faced Christians down through the ages. We can almost feel that same temptation when we recall the name we have given to the center part of the church. The part of the church in which the congregation sits has been, and still is, called the *nave*. It comes from the same word as "navy," a Latin word for ship.

When we are in the church, we ride out the world's storms and floods in a very secure ship. We may sit there and feel exactly like the hymn verse we used to sing:

The storm may roar without me
My heart may low be laid
But God is round about me
How can I be dismayed?

(Anna Laetitia Waring, 1820-1910)

In the church, in our ship, we are safe. Here God is with us. Here we are with our family, the family of faith. Here we can trust each other. Here we don't lock doors or look furtively over our shoulders or shrink from dark corners. In the church, in the nave, our family is safe from the raging flood, the roaring storm, the misery, and the death on the outside.

How nice it feels to be inside. How comfortable we all are. How good it feels to sit side by side and sing and pray and shut the doors against the deep and deadly and threatening world outside. How nice it would be if we could just stay this way, protected against the sins and threats and disappointments and pains and death in the world outside. Why couldn't we just stay here?

As we sit silently and think about how comfortable we are in our nave, our ship, and how wonderful it all is, and how great it feels — as we sit in silence and bask in the blessing of it all, we hear a noise in the distance. We can't quite make it out. It gets louder now. It's a whimper that grows to a cry that grows to a wailing *shriek*.

Someone is dying outside. Someone on the outside wants in. Someone would like to share our comfort, our safety, our joy. Someone would like to climb into our ship and join our family.

We have to think about that. It takes some considering. We don't have much time to think, though. The shriek gets more urgent. If we don't hurry, he's going to die; he's going to drown out there.

Someone goes to the door. A brave and compassionate believer goes to the door. "I'm going to open it," he says. Some disagree; some argue with him; some are afraid of the sea and of the storm. Some are more afraid of that person who shrieks and pounds and pleads to come in. The believer will not be swayed. He opens the door.

The person comes in. They look at him. They study him. They examine him with great care. That's strange. He is no different. He is just like the rest of them. He could be one of the family. Soon they are accepting him, offering him towels and dry clothes, crowding around him, happy and chattering and excited to have him inside.

Then a small group of believers begins to talk among themselves. They whisper and they gesture and they look very concerned. What they are saying is this:

> *"Perhaps there are others out there. Perhaps some others who could join our family are out there struggling, swimming, drowning. Perhaps we could save others if some of us went outside."*

On that day the church, the ship, the nave, sent out lifeboats looking for survivors — and on that day the church became much less safe, but much more capable of doing its true work: saving a fallen, drowning world, after the pattern of the Carpenter who saved us all from doom and terror one dark Friday afternoon.

And from that day on, the church of Jesus went forth like the sons of Noah, "to be fruitful, to multiply, to bring forth abundantly on the earth and multiply in it." (Genesis 9:7)

Proclaim to every people, tongue, and nation
That God, in whom they live and move, is love:
Tell how he stooped to save his lost creation,
And died on earth that man might live above.
Publish glad tidings, tidings of peace;
Tidings of Jesus, redemption and release.

(Mary Ann Thomson, 1834-1923)

2

Escape Through Water: The Red Sea

Genesis 14:10-14

Many thousands of people left Egypt. They started out the morning after the Passover, many thousands of "men on foot, besides women and children. A mixed multitude also went up with them," it says, "and very many cattle, both flocks and herds." (Exodus 12:38)

The people of Israel had a tough time getting out of Egypt. Old Pharoah didn't want to let those people go. Old Pharoah's stubbornness practically ruined his country in plague after plague, calamity after calamity. After plagues of blood and frogs and gnats, after plagues of flies and boils and hail, after plagues of locusts and darkness — finally came the Passover. Egypt went through plenty because of Moses and the people of Israel. Toward the end, the servants and counselors of Pharoah said to him:

> How long shall this man (Moses) be a snare to us? Let the men go, that they may serve the Lord their God. Do you not understand that Egypt is ruined?" (Exodus 10:7)

When Passover happened, when the first-born began to die, when the wails and screams of mothers through all the land of Egypt rose up to heaven, at last Pharoah said to Moses and Aaron and to the people of Israel, "Go." So all the people of Israel left the next day.

They started out from northern Egypt, heading east. They started from the town of Rameses, named after the two Pharoahs who ruled Egypt when Moses was just a baby in that basket in the bulrushes, and when he stood in the desert and saw God in the burning bush, and finally when he represented his enslaved people during the plagues. We are talking about events that occurred twelve or thirteen centuries before Christ.

When Rameses II finally let Moses go, Moses and the people left

Egypt and traveled until they hit water. We call this story the Crossing of the Red Sea. It is second only to the Passover as an important event in Jewish history. It was another of God's amazing and saving water miracles.

Just before that miracle, the men, and women, and children of Israel and all their herds and flocks were in real trouble. They were in a pinch, a squeeze, a mess, that seemed to offer no hope. That mess, that crunch, all started when fickle Pharoah changed his mind once again. He had repeatedly said "No." But when the final fatal plague descended, when the first-born all had died, then Pharoah said, "Go."

Not more than a few days after Moses and the people had gone, Pharoah changed his mind, once again, and said,

> "What is this we have done, that we have let Israel go from serving us?" (Exodus 14:5)

Pharoah got his army together and his chariots. There were 600 of them the Scripture says, and they all took off after Moses and the people. When Pharoah's chariots and army caught up with the people of Israel, they were camped next to the Red Sea.

There was no escape. The waters stretched both north and south. The Israelites had their backs to the water, and, out on the land in front of them, all they could see was Pharoah's army. They were in big trouble. There was slavery or death by the sword ahead of them and death by water behind them. They had no weapons and no boats. It was surrender or swim, surrender or die. The people cried out to Moses:

> "It would have been better for us to serve the Egyptians than to die (here) in the wilderness." (Exodus 14:2)

On that day the people of Israel learned patience and faith. As they stood there quaking in fear, Pharoah's army in one direction and water in the other, Moses said to them:

> "Fear not, stand firm, and see the salvation of the Lord, which he will work for you today; for the enemy whom you see today, you shall never see again. The Lord will fight for you . . . you have only to be still." (Exodus 14:13, 14)

Think of that! What astounding advice: "The Lord will fight for you . . . you have only to be still."

How many times in our lives, after we have run headlong into one bad decision after another, have we wished someone had given us such advice and we had found the courage or had had the wisdom to follow that advice? It takes courage to stand pat, and that is exactly what Moses was telling his people to do. God often gives *us* that advice.

Standing pat is the most common advice Christian marriage counselors and pastors give to young couples who are in trouble — and to older couples, too. "You have only to be still." That's tough advice, but sometimes it's best. The amazing truth about most marriages is they get better and better. That's why so many marriages in our parents' generation lasted. They endured, they survived, by simply waiting. Often the best advise is "Just wait. Be patient."

Today's divorce rate partly reflects the shock many young couples feel when the honeymoon is over. When they begin to disagree over how to spend the money or where to spend the vacation or whose relatives to spend the weekend with, or who is going to spend the night rocking the baby, by then their patience is spent as well.

When married people begin to disagree about these things, they may think the bottom has fallen out of their marriages. They have watched so many movies and TV shows and read so many stories and articles and taken so many of those dumb marriage and sex quizzes, they can no longer reason out what marriage really is. And when the inevitable happens, when the normal give-and-take, the shout and nag and sulk of marriage, sets in, they think it's all over.

From then on, things seem to get worse and worse for some couples. They fight more, sulk more, spend more and more time apart. At that point they see themselves in the same kind of trouble, in the same kind of dilemma that Moses' people were in. They are threatened from both sides and seem to have a hard decision to make. They are between a difficult marriage and a frightening separation or divorce. They are between Pharoah's armies and the water, between the Devil and the deep blue sea, between the rock and the hard place. They are in a dilemma.

At that point they are often asked to wait. In a troubled marriage, that may mean a fairly long wait — more than weeks, sometimes months, sometimes even years. It may mean many sessions

of counseling; it may mean reading and studying and thinking a lot; it may mean asking for advice and help. And, for a Christian couple, it should also mean sharing their concerns with brothers and sisters of the faith — and it has to mean prayer and more prayer.

After a time, as if by miracle, of working at it and waiting for it and praying for it, the answer comes. It comes as it came to the people of Israel. It comes out of the impossible. God makes a way *through* the impossible. With the sword ahead and the sea behind, God says, "Turn around and head for the water." "The enemy you see today, you will never see again." What a dream. What a promise.

It's true. God makes paths through the impossible. God can part the sea of troubles that block our way so that we can walk through on dry ground. That also takes faith.

Imagine the fears that riddled many of the people of Israel as they walked where there used to be water. Imagine how their fears multiplied as they got farther and farther out into the dry basin, as the shore fell farther and farther behind. Maybe some of them still thought of the shore as the only place of safety, even though they had to share that shore with Pharoah's army. But Moses said, and God said, that safety was in the sea. God said they should ignore their fears and head for the other shore.

This is where most of us get hung up. When we're in deep trouble, when we face the dilemmas of life, we wait for a sign; we wait for some Moses to come along and strike a path through the sea of troubles that surrounds us. But when the message *does* come, when the seas *do* separate and we get a glimpse of that path, of that hope, of that way, when we finally see another chance, sometimes we're too petrified to move.

This isn't a problem only in marriage. It is a problem in all the hard decisions of life. I knew a man some years ago, a widower, who had lived alone so long that he really didn't know any other life. His relatives finally convinced him he should take a trip to visit his parents' old province in Holland. They finally talked him into it — or so they thought. He made arrangements, packed, planned, even bought his plane tickets. But when it was almost time to leave, he couldn't. He just couldn't do it. He hadn't the courage to try a new way, to open a porthole in his life.

He returned his ticket, unpacked his things, and was so ashamed of his failure that he wedged himself into an even more lonely slavery. He sold out to his loneliness and to his fear. After that he lived

in his house by himself for less than a year. Then he was dead. He couldn't cope with the world so he just curled up and died.

Sometimes God opens up a way for us in the midst of our fear and loneliness and slavery. Sometimes it's our last chance. That is no time to be afraid. God didn't create us to spend our lives cowering between the sword and the sea. God didn't intend us to fear death by people so much, or death by nature so much, that we would just stay there hiding in between.

We can't wait forever. Sure, we sometimes have to wait, we sometimes have to be still and let the Lord fight for us, but when he makes a way and shows us that way, then he expects us to move and move fast.

Too many of us have messed up one good chance after another because we didn't recognize God's opportunities, or wouldn't take the risk if we *did* recognize them:

Take a new job? I couldn't. What if it doesn't work out. What if I give up this job and the new one doesn't work?

Get married? How could I? What if it doesn't work out? What will I do then?

Go to school? At my age? How could I? Won't the younger ones laugh at me? And what if I flunk out?

Go out for the team? Try out for the choir? Enter the contest? Submit my manuscript? What if I don't make it? What if they don't like me? What if they reject my work?

Take a language course? A science course? Go without? Deprive myself? Take a risk? Take the plunge?

All of life is a risk. When Moses led the people out of Egypt he was an old man, 120 years old. He had lived in Egypt *all his life.* They all had. As a people the Israelites had been slaves in Egypt for 430 years. Like the widower we spoke of earlier, they didn't know any other life.

But Moses had heard the Word of God. Moses dreamed of a promised land. He could see it and smell it and taste it. The land of milk and honey was out there somewhere. That hope, that promise, that Word became Moses' message. He told his people to

strike out in patience and in faith. It meant heading for the wilderness, and when the enemy backed them up against the water, it meant walking through that water, walking through death to life. And of the waters around them and the armies behind them, and of all the waters and enemies we all have faced and still face day by day, God says:

> *"Fear not, stand firm, and see the salvation of the Lord, which he will work for you today; for the enemy whom you see today, you shall never see again. The Lord will fight for you . . ."*

And fight for us he did. The Exodus prefigured for the church a later, even more spectacular escape. When Jesus squared off with the Evil One at Golgotha, a showdown came about that makes the onrushing of Pharoah's army look like the parade of toy soldiers, so great is the contrast — and the consequence. Like Moses, Jesus led all the faithful on to safety and a victory whose worth cannot be measured.

> *Lead on, O King eternal;*
> *We follow, not with fears,*
> *For gladness breaks like morning*
> *Where'er thy face appears:*
> *Thy Cross is lifted o'er us;*
> *We journey in its light;*
> *The crown awaits the conquest;*
> *Lead on, O God of might.*
>
> *(Ernest Warburton Shurtleff, 1862-1917)*

3

Washed By Water: The Jordan

Matthew 3:13-17

When a priest in the medieval Christian church stood before the altar of God and raised the bread of holy communion above his head, he said in Latin, *hoc est corpus,* "This is the body." That was the supreme moment of mystery; that was the moment of miracle; that was the moment of change. At that moment the medieval Christian believed that ordinary bread became the body of Christ.

Hoc est corpus, "This is the body." What the ordinary person way back in the corner of the cathedral thought he heard was not *hoc est corpus,* but "hocus-pocus." That word soon came to mean magic, mystery, seeing the unbelievable happen before your very eyes. The medieval priest felt that mystery very deeply when he spoke those words. It was a solemn and scary moment. Martin Luther was so frightened the first time he spoke those words as a novice priest that he nearly fainted right there at the altar.

Today, five hundred years later, the consecration of the elements is still a moment of high excitement and mystery — and even *fear* as we hold God's bread in our hands and say, "This is the body . . ."

The Lord's Supper uses bread and wine. The Sacrament of Baptism uses water. Somehow water doesn't hold the same kind of mystery because no one expects water to become anything different. Water doesn't represent anything. The bread of communion both represents and is the body of Christ. The water of baptism, however, is simply water. It is merely the agent of washing. In fact, that's what the word baptism means: *baptizo* (Greek), "I wash."

Water is great for washing. Water can dissolve almost anything. Nearly half of the world's known chemicals can be found dissolved in the world's natural waters. Some substances form solutions *with* water; other merely go into suspension *in* water — such as the silt in the Mississippi River or the soapy murk in a tubful of water,

residue that swirls down the drain after Suzie's bath.

The amazing thing about a river full of water is that no matter how many chemicals are dissolved in it, or how much mud is suspended in it, or how many Suzies uncork their bathtubs into it, when the sun hits that water and evaporates some of it to form a cloud, the water in that cloud is pure. The river may be absolutely filthy, but you can always distill pure water from it.

There has always been the same amount of water on this earth. There may be wet years and dry years, but all the water is somewhere. We use it over and over again. Some of the same molecules in the water we wash in today may have been in the waters Moses parted with his staff, or the water in which David washed his feet, or the water the woman of Samaria drew for Jesus, or that John Calvin used in a baptism.

There is something very satisfying about washing. That must be what we appreciate about baptism. Because baptism is a washing, it makes us feel clean — even if we just watch — and we like feeling clean. Nothing feels better when we are extremely dirty than does soothing, cleansing water.

Everybody has his own "dirty story," I suppose, but the dirtiest I can remember being was when Martin Olson and I tore down an old house one August. I knew it would be dirty work, but I never dreamed it would be so bad as the day we pulled down the attic ceiling. Down came plaster dust and street dust — and shingle dust — sixty-five years worth of dust that stuck to our sweaty arms and faces on that ninety-five degree afternoon. We would have made a perfect before-and-after picture of the washing of baptism on that day: two absolutely dirty people washed clean.

Sometimes, though, we wash and we still don't feel clean. Maybe that's the difference between dirty and filthy. Even on that ninety-five degree day, caked with grime, Martin and I sat and ate our lunch without even washing our hands. We thought nothing of it. It's not so bad to eat with dirty hands. It's different, though, when you're filthy.

I remember my dad telling me a filthy story. It goes back to outhouse days in south Minneapolis, I'd guess around 1915. One of the common Halloween pranks in those days was to take a stout ten foot pole, wedge it under the ridge in the back of an outhouse, and then, by pushing forward and upward, you could topple that little building frontward on its door.

That's what Dad and his friends were doing. Dad and a kid they called Eddie Upstairs were watching the street, while Pinhead, Worms, Peckie, and Eddie Downstairs tipped over a whole block of outhouses.

Everything went fine until they tried one with a rotten foundation. Then, perhaps to prove that sin often has its own rewards, Pinhead and Worms pushed too hard and Peakie fell in.

That's the difference between dirty and filthy. You don't climb out of a hole like that and go directly to Aunt Polly's Halloween taffy pull. An experience like that gives you a filthy feeling, a defiled feeling. Only a lot of scrubbing can wash off that feeling. You can eat lunch with dirty hands, but not with filthy hands.

Problems arise, however, when the dirt or the filth or the stain is somehow connected with wrong or evil or sin, because that produces guilt. Dirt and even filth wash off; guilt is something else. Guilt isn't on the outside; you can't really scrub it off. Plain water, ordinary water, can't touch guilt.

If Shakespeare's play, *Macbeth* is about anything, it is about guilt. *Macbeth* has two memorable scenes that involve washing and guilt. In the beginning of the play, Macbeth and Lady Macbeth conspire to kill the good king, Duncan. When murderer Macbeth comes back from the king's bedchamber with bloody hands, Lady M. says to her husband:

> *"Go and get some water,*
> *And wash this filthy witness from your hand."*

At that Macbeth notices his hands. It's not just a filthy witness; it's not just a bit of blood. That stain is innocent blood. That filthy business is the guilt of a cold-blooded murder. Macbeth stares at his hands and says:

> *"What hands are here? Ha! they pluck out mine eyes.*
> *Will all great Neptune's ocean wash this blood*
> *Clean from my hand?"(II, I, 58-61)*

Lady Macbeth pooh-poohs all his worries. "A little water clears us of this deed," she says. But much later, as the play ends, we see her under a nurse's care, gone mad. The doctor whispers:

> *"What is it she does now? Look, how she rubs her hands."*

Her nurse answers:

> *"It is an accustomed action with her, to seem thus washing her hands:*
> *I have known her to continue in this a quarter of an hour."*

It is apparent that, in her trance, Lady Macbeth sees spots of blood. She lifts her fingers to her face and says:

> *"Here's the smell of blood still: all the perfumes of Arabia will not*
> *sweeten this little hand." (V,iii, 56,67)*

Guilt. The incredibly indelible stain of guilt. Guilt drove Macbeth and his lady to madness and to death; it will drive any of us to death.

There is nothing so real, so haunting, and so crippling as a feeling of guilt. Ordinary water can wash away dirt; ordinary water can even wash away filth. But the stains and spots of guilt require extraordinary water.

Those who have a real hold on the Good News know that there *is* such an extraordinary water. Jesus took ordinary water and made it extraordinary by connecting it to the Word — to his words really. Words of promise. "By water and the Word," we sing in the hymn. Baptism: the water and the Word. A washing with a promise.

When I was little, my mom used to give me colossal baths, real scrubbings. I'm sure I just shone afterwards. Mothers seem to appreciate that shiny, scrubbed look. Sometimes, though, there wasn't time for one of those momentous baths. What I got then was called a *katavask* — a cat wash — a lick and a promise.

Maybe that's how we should see baptism, as a *katavask* — a lick and a promise. A little water or a lot, a ritual washing; it happens only once. The promise in that simple washing, however, is gigantic. God promises it will last forever, that as long as we keep the faith and ask for forgiveness, our sins are washed away daily, hourly, every minute of every day of every year of our lives. Through baptism we become Mr. Clean, Mrs. Clean, Miss Clean. God's forgiveness makes us shine like scrubbed kids. We glow. We radiate.

We need that washing because we were born with sin. We continue to need the promise that went with that washing because of the sins we commit day by day — and because of the guilt of that sin.

Guilt and sin are the very stuff our lives are made of. Since Adam

and Eve, since the beginning, since the fall of humankind, we have all needed to be picked up out of the dirt and filth, and washed off, scrubbed up. Baptism is that washing.

But, we ask: if baptism washes away the stains and the guilt of sin, why in the world did Jesus want to be baptized?

John the Baptist had the same question. John was one of the first to recognize Jesus as the Christ of God and he thought it was very strange, in fact absolutely crazy, that he, an ordinary, sinful man, was asked to baptize the chosen one of God, the sinless and perfect Christ Jesus. "*I* need to be baptized by *you*," John said. Why ". . . do you come to me?"

Jesus had an answer. Jesus always had an answer. "To fulfill all righteousness," he said. I don't know what that means exactly, but I think it was a part of his becoming one of us. From the beginning, Jesus struggled to be one of us, to be a human being, a person. He was born as we were born; he was dedicated and circumcized like any other Jewish boy; he ate, slept, worked, and played as one of us; he grew up like the rest of us.

But when Jesus began his public ministry, his real work, he must have found it harder and harder to remain one with us. He was baptized for forgiveness even though he needed no forgiveness. He practiced his family religion even though he himself would later start an entirely *new* religion. And, in the end, he died just like the rest of us — but not really. If the wage of sin is death, Jesus didn't earn that wage. He didn't deserve to die on that cross — yet he *did* die.

On that rugged cross the blood of Jesus was shed and, in that blood, we see still another kind of washing. Some of the old hymns portrayed that washing very vividly: "Washed in the blood of the Lamb," we used to sing. Or how about this verse from the old hymn, "I Lay My Sins on Jesus":

> *I bring my guilt to Jesus*
> *To wash my crimson stains*
> *White in his blood most precious*
> *Till not a spot remains.*

> (Horatius Bonar, ca. 1845)

Or this one:

> *There is a fountain filled with blood*
> *Drawn from our Savior's veins;*
> *And sinners plunged beneath that flood*
> *Lose all their guilty stains.*

> (William Cowper, 1771)

That's pretty heavy imagery, but that's about the size of it. It's Lady Macbeth in reverse. Somehow or other, when Jesus died, his holy and precious blood spattered over the entire world. There's a spot of his blood on every one of us and that spot won't wash off. We can cover it up; we can pretend it isn't there, but we are marked. We are marked with the blood of the Lamb.

That blood can cleanse us; that blood can save us. Christ's blood washes us clean and baptism reminds us of that. When the little bitty babies and the children and the young people and the adults are brought forward in every kind of church and chapel around the world week after week and year after year, they are indeed washed with water, they are indeed cleansed — but they are also marked with the blood of the Lamb, the Lamb without blemish and without spot.

That blood, that water, that washing takes care of all the dirt and filth and stain. That washing also takes care of the guilt. Baptism is a complete washing, once and for all time. In him and through him and with him we are washed clean — forever and ever and ever.

O Jesus, let your precious blood
Be to my soul a cleansing flood.
Turn not, O Lord, your guest away,
But grant that justified I may
Go to my house, at peace to be:
O God, be merciful to me!

(Magnus B. Landstad, 1802-1880)

4

Wine from Water: The Wedding

John 2:1-11

Wouldn't you think that when early man and woman learned to make wine they thought it a miracle — or at least a mystery? Picture some prehistoric person putting a bunch of grapes in a stone jar, then getting so busy hunting pterodactyls for a week or so that they forgot all about those grapes. Imagine their surprise when they finally came back to find the whole business bubbling and gurgling away with great vigor. That amazing process is called fermentation.

Fermentation is an important process in this world — and not just for making wine. Even in early times fermentation was used not only for beverages, but for cheese, for certain textile processes, for tanning leather, and, of course, for the mild and brief fermentation that yeast causes in bread.

Our industrial society has since used fermentation to produce lactic, citric, and acetic acids that are important to the food and chemical industries. Other modern fermentations produce solvents like acetone, fuels like butanol, explosives, plastics, and all sorts of marvelous substances. Modern agriculture has always depended on fermentation to process chopped crops in silos and harvestores, but now more and more farmers are trying to use that same process to produce not only feed but gasahol.

At its roots, though, fermentation is a very simple process. You leave some grapes, some water, and some sugar in a jar for a while and you'll soon have wine. That is one of nature's simple miracles, one of the many miracles that is built into the fiber and structure of this world of ours. We marvel at this miracle along with others we have associated with water.

But fermentation is a slow miracle. A complete natural fermentation process takes weeks. Imagine that miracle taking place instantly. That would be a *double* miracle. And imagine it taking

place with no grapes. That would be a *triple* miracle. Water into wine — *a triple mystery.*

It all happened, it really did, in a little town called Cana in Galilee, about 2000 years ago. It happened because there was a wedding. It happened because Mary, the wife of Joseph, the mother of Jesus, was there. It happened because her son came along. He took that simple, ordinary stuff we have been studying — plain water — and changed it into wine.

It was a strange and quiet and private miracle. It happened in the entryway of the wedding hall. There was no hocus-pocus about it, no flash of lightning, no magic words or incantations. So subtle, so silent was the miracle that only Mary and the servants really knew what had happened. One minute there were six jars of water; the next minute there were six jars of wine.

It was good wine. The best. The steward was amazed at the excellent quality of the wine. Water into wine. Six large jars of ordinary water into extraordinary wine. Jesus' first miracle, his first strange miracle.

What interests me particularly about this miracle is not that water became wine; not that the Christ of God was involved in something so frivolous as a wedding dance; not even that he would make wine in a world where alcohol addiction was and is one of our major health problems. What interests me particularly about this story is what Jesus said to his mother: "O woman, what have you to do with me? My hour is not yet come."

Those sound very much like angry, peevish words. We can't help but compare them with a scene that falls later in Jesus' ministry, when he was preaching and teaching crowds along the Sea of Galilee. At one point Jesus must have been speaking to a crowd in a house or building — maybe it was Simon Peter's house. The story goes like this:

> And his mother and his brothers came; and standing outside they
> sent to him and called him. And a crowd was sitting about him.,
> and they said to him, "Your mother and your brothers are outside,
> asking for you." He replied, "Who are my mother and my
> brothers?" and looking around on those who sat about him, he said,
> "Here are my mother and my brothers! Whoever does the will of
> God is my brother, and sister, and mother."
>
> (Mark 3:31-35)

Now this is a beautiful saying for those who try to do the will of God. That even goes for you and me. If we try to do God's will, Jesus calls us his brother and sister and mother. That's really exciting. That makes us feel pretty good.

But how do you suppose Mary and her family felt on that day so long ago? It must have hurt something awful.

Children always have ways of hurting their parents. They run away from home, they get married too young, they fail in school, they become sullen and withdrawn, they fall into bad ways. Sometimes they seem too slow in getting on with their life's work. That is happening a lot more these days than it used to. More than in former generations, today's young people are postponing decisions about their futures; they are in no hurry to make that dive into the mainstream of life. They are hanging around home; they are staying in college for extra years; they are working at jobs below their ability level — and, in the process, they are getting to be twenty to twenty-five years old and seeming not to be getting *anywhere.*

If this is going on in your home, you can easily imagine how Mary felt. In those times young men went to work at age twelve or thirteen, girls got married at thirteen or fourteen. Everyone started young in those days — everyone but Jesus. There he was, thirty years old, and not really doing what he seemed destined to do.

Even before he was born, Mary had had dreams about Jesus. She had been visited by the Spirit and had seen some promising signs. Joseph had had visions and dreams too, and even cousin Elizabeth knew that Mary's child was destined for something great.

But here was Jesus, thirty years later, and nothing had really happened yet. Do you suppose Mary nagged him a bit? Did she urge him to get busy and become a rabbi? Did she push him like a mother of today would push?

We don't have answers to those questions, but I'll tell you this: it must have been thrilling for Mary to see her son, her thirty-year-old son, finally — finally — get busy with his life's work, and finally, begin to get some recognition, too. It must have been great for her to see the crowds gathered about her son, to hear people talk about him on the street corners around Galilee, to hear people exclaiming over his healings, to hear them recounting his teachings and laughing at his put-downs of the stuffed-shirt Scribes and Pharisees. It was nice to have a famous son. That's what the promises and visions and dreams had been all about. Mary, like any mother,

must have loved it.

But Jesus was a strange son. "Whoever loves God is my mother," he said. That's a nice saying for anyone but his real mother. It's a terrible put-down for her. She must have *felt* terrible — and it wasn't the first time either. Mary, standing outside that house, watching that crowd, must have thought back to another crowd, a wedding party at Cana. Those earlier harsh words might have rung in her ears: "Woman, what have you to do with me?"

It is always hard to be the private family of a public person. Jesus' mother was not the only one. We could tick off on our fingers a whole list of strange private relationships among public figures we have read about and heard about. Think of terrified Isaac, lying on that altar, watching his father raise the knife; think of Pilate's frantic wife who had nightmares about Jesus; think of Eva Braun's strange relationship with Hitler, of Eleanor Roosevelt, Jackie Kennedy, Margaret Trudeau, and dozens and dozens of other political and show-business figures — people who were twisted, hurt, hampered, outraged, spurred on, or, in some other way, changed by being related to a famous or infamous public person.

Most public people don't have much time to look after their private lives, and the more public they are, the harder it is. Before the '76 election a reporter asked one of Gerald Ford's children how he would feel if his father won that election — or lost it. His reply was, "If he wins, good for him; if he loses, good for us." He knew they'd get their father back if he lost that election — and that is undoubtedly what happened.

"Woman, what have you to do with me?" Jesus said. Mary could have answered, "I have had a great deal to do with you. I submitted to the Spirit when you were conceived. I gave birth to you. With my own milk I nursed you. I raised you through your childhood, protected you, fed you, loved you. I *still* love you. *That's* what I have to do with you; I love you."

Jesus would have been touched, we can be sure, by such words from his mother. He knew she felt this way; he knew she loved him even though she didn't say a single, solitary word. It was important to have his mother's love as Jesus faced his gigantic mission, but hanging around home to care for her wasn't part of the plan. Jesus was laying a foundation for a new religion, a new way, and he had to break, and break decisively, his ties with his family. "Woman, what have you to do with me?"

Jesus made that break. The rift, the division, lasted almost three years.

Jesus addressed some of these broken relationships, when hanging on the cross, he said to Mary, "Woman, behold your son," and when he said to young John, "Behold your mother."

As he hung there on the cross, minutes before his death, he took time to heal that three-year ache, that painful separation. Just minutes before his death he arranged an adoption.

Jesus hadn't forgotten his mother. There, from the cross, he arranged for John to look after mother Mary — and from that day John took her to his own home.

It is interesting to notice that when Jesus was hanging there, dying on the cross, no one mentioned his brothers and sisters. Maybe when they heard he was being crucified one might have said, "Well, it's good enough for him. He got too big for his britches. He wouldn't even recognize us, his own family." Or another might have said, "Do you remember the time I invited him for dinner — me, his own sister — and he said he had to go see about some sick person?" Who can be more cruel to each other than members of a bickering, fractured family? Remember the prodigal son's elder brother?

The family of Mary and Joseph must have suffered plenty because of the fracture, the rejection in their family — but the rejection was not forever. Jesus did arrange for his mother's care as he hung there dying, but there was still another episode, because death was not the end for Jesus. He came back. He walked this earth again for forty days. I'm betting Jesus went home during that time. I think he must have made things right with his family after he was raised from the dead.

If you find that hard to believe, then read carefully the account of those early days of the church (especially Acts 1:14) and of the day of Pentecost. On that day, when the Holy Spirit came to them, Peter was preaching (Peter who had denied his master three straight times). And who was listening to Peter's sermon? There were Jesus' brothers: James and Joseph and Simon and Jude. There they were, and Jesus' mother was there, too. Peter was preaching; Mary and her family were listening. They were together. They had put the mystery of Jesus together and that's what brought *them* together.

This is an encouraging word for all of us. No, we can't rise from the dead and come back to straighten things out in our families, but there is hope nevertheless. There is hope in our own homes where

even our faith can't seem to hold things together sometimes. There is hope even when things seem so broken and fractured and bitter we wonder if there is any way out.

We should be encouraged to see in Jesus' own family the trouble was finally worked out. The risen Christ and the power of the Holy Spirit drew his family together at last.

God's promise was offered to the world in Jesus. Mary's family finally became a part of that promise. They drew together around the risen Christ.

Your family and mine are also a part of that promise. The risen Christ can draw us together, too — and he will if we let him. It may take some time, and it may take some work, and it may take some patience and some compromise and some pain, but the risen Christ can do it. He can pull together all the twists and sprains and gaps and breaks in our fractured families. He can teach us to love.

O Holy Spirit, bind
Our hearts in unity
And teach us how to find
The love from self set free;
In all our hearts such love increase
That every home, by this release,
May be the dwelling place of peace.

(F. Bland Tucker, 1895-)

5

Saved From Water: The Storm

Luke 8:22-25

Jesus performed many miracles during his ministry. These miracles didn't really prove that he was the Son of God, but they certainly did draw crowds. The disciples who have relayed these stories to us through the Gospels were part of those crowds, sometimes as reporters, sometimes as witnesses. The disciples, for instance, didn't really see the water become wine. That happened in an outer hallway. They must have heard the details from the servants or from Mary.

Other miracles they saw with their own eyes, like most of the healings and the raising of Lazarus from the dead and the time Jesus walked on water. In a few rare instances, the disciples actually participated in the miracles, like the feeding of the 5000 or the stilling of the storm. These were special miracles. In their own hands they held and distributed the miraculous bread and fish of the great feeding, and with their own hands they bailed the boats and manned the oars during the storm. To hold a miracle in your own hands can be a thrilling business.

If I could summon from the heavenly places one of the disciples to give us a first-hand account of the stilling of the storm, I guess I would ask for Peter. Peter ought to be a good story teller; he was never at a loss for words. Peter was also a man who loved challenge and excitement and adventure. Above all, Peter, more than any of the others, was a man of water.

I invite you, then, to use your imagination, to imagine we actually have here with us Saint Peter, the fisherman, the disciple, the bishop, the man of water, the man of the sea. Imagine him visiting us, talking to us, retelling once again the story of the storm. Listen to Peter's eyewitness account of a miracle:

(Peter's Monologue)

Thanks for inviting me. I love telling this story. I love storms, and water, and the sea. Do you know that I began going out in the boats with my father on my sixth birthday? The sea is my life. Fishing is my life — or at least it *was*. I fished until Jesus came along. He asked my brothers and me to become fishers of men; then we began to work for him. I still work for him. That's why I'm here.

Did you ever say to yourself, "If only I could talk to one of Jesus' disciples, then I'd get some answers". Well, here I am and now's your chance. Suppose you could ask one question, just one. What would it be? Think hard now.

Narrow it down to one. One question about Jesus. One probing question. I can feel it; I can hear it. The question most of you are asking is this: "What was Jesus really like?"

What he was like, at least what he seemed like to us disciples, was like the kind of friend you always wanted to be doing things for. We *did* do a lot of things for Jesus too, things he asked us to do — and a lot more that he didn't. We did our best to keep his life from getting cluttered up: the detail things, like getting food, arranging for land travel, boats, places to stay overnight in bad weather, things like that. When *we* did that, then he could concentrate on preaching and teaching and healing.

That's what he was doing that day by the seashore, the day of the storm. I remember that day very well. Jesus had been teaching a large crowd all day, and healing, too. It was evening and we were all dog tired and hungry. Jesus looked at me and pointed out over the Sea of Galilee and said, "Let's go across to the other side." He looked right at me when he said it. Then he turned to my brother Andrew. "Let's go across," he said. Andrew turned to me and whispered, "Now? He wants us to start across now?"

"Shush," I said, "He'll hear you."

"I don't care," he said. "It's going to be dark in an hour and there's no moon."

"I know that," I said, "but he wants to go."

Andrew said, "Where I want to go is to sleep. He says 'Let's go across the lake' just like there was nothing to it, just like the boat would sail itself across. We'll be up all night. I'm tired.

"I know you're tired," I said to him. "I'm tired, too. He must have a reason."

"Maybe his reason is that he wants us all to drown. Look at those clouds. We'll sail right into a storm. Just look."

Andrew was right. There was a storm scowling its way toward us from the north. I thought if we hurried we could beat it across — and certainly there would be plenty of wind for sailing. I got Andrew and we more or less whisked Jesus away from the crowd. We didn't give him time to pull off his cloak or anything. He just stepped into the boat and off we went. When we were out some distance, I tried to persuade him not to go across. I suggested we sleep in the boat offshore where the crowds wouldn't bother us. He just shook his head.

Then I suggested that by tacking out to the north a few miles, we could make our turn and come back to shore around the peninsula and put in there for the night. The crowd would think we had gone across and we could wait until morning — or at least until the storm had gone by. He just looked at me in that special way of his. He didn't say a word. "You really want to go across?" I asked. He nodded.

We rigged sail and started due east. There was plenty of wind. We were just sizzling along. If you've ever sailed you know what I mean. We had a foam trail going back as far as you could see. About twenty minutes later, I looked back and Jesus was curled up in the stern, asleep.

What really got me that night were the other boats. We had two boats ourselves, but there were five other boats that sailed with us. They didn't have to go. Well, I suppose we didn't have to go either, but if *you* had been a friend of Jesus and he had looked *you* in the eye and said, "Let's go across the lake," you would have gone across the lake; take my word for it.

Those other boats didn't have to go. I guess they didn't want to lose him.. I don't know exactly how to say this. The thing is, you might say Jesus was the "action" that summer. He was making things happen around Galilee. He was fun to be with, exciting. It was spooky sometimes, with the healings and all, and you never knew what would happen next, but it was an exciting summer. I'll bet if there had been enough boats around, half the crowd would have sailed with us, storm or no storm, even at night. They were a strange, unpredictable crowd.

That crowd was sometimes a problem. Sometimes they were a downright pain. It was our job mostly, to keep the crowd under control. Let me tell you that was almost impossible, especially in those early months. How could you hold back sick people who thought

they could be healed just by *touching* Jesus? Oh, they got pretty nasty, some of them. One man was so anxious to get near Jesus that he hit me across the knees with his crutch, and several so-called "ladies" kicked my shins in those crowds.

You couldn't predict Jesus either. Like that time you may have read about in your Bibles, the time with the kids. Early that afternoon he had said, "Could you get the crowd back a little? It's very confusing up here." Well, we tried, we really did. The trouble was the ones who wouldn't move that day were some young mothers carrying children. We were shouting at them and kind of pushing them back just when Jesus said, "Let the little children come to me. " When you people read that story it makes us sound like a bunch of child molesters. Well, we weren't. We were just trying to keep things under control. I tell you, it was hard in those early months.

But I'm getting away from my story. You call it a miracle story, and that's what it was. Talk about water. We all saw too much water that night — walls of water, sheets of water in the wind, water sloshing into the boat. Then, all of a sudden, Jesus actually stopped that storm, that water, dead in its tracks. I've never seen anything like it.

Now there'll be a few of you who will consider some other theories, like maybe we sailed into the eye of the storm and that's why it got so calm. That could have happened, but it didn't. I considered that theory myself the next day. But I had been in the eye of a storm before, twice, and it wasn't the same. Andrew agreed with me. It wasn't the same.

We also considered it could have been one of those storms that come up fast and stop fast. I've been in dozens of them and so have most of you. It might have been one of those, but how then did Jesus know the exact moment to wake up and command the storm to stop? And anyway, even those fast-stopping storms do die down. This one didn't die down at all, it just stopped. "Snap!" Just like that. I've never seen anything like it.

The only real explanation — and I thought about it a long time — was that Jesus actually had control of the weather on that day. He didn't always; or maybe it didn't always matter. I remember how we got rained out something terrible on another day when he was teaching and preaching. The rain poured down and the whole crowd got drenched. Jesus could have stopped that one too, I guess, but I don't think it really mattered to him that much. Nobody was in any danger.

Do you know what he did? He just stood there smiling, sopping wet, hair matted down, water running down his cheeks, and he made up this story about rain being like forgiveness. It was a beautiful story about a boy who had lied to his mother. It's not in your Bible — and do you know why it's not? Because Matthew and Luke and all those other so-called evangelists were running up the hillside to hide under a tree, that's why. I was the only one who stayed out in the rain to listen. I love rain. I love water.

I used to tell that story sometimes in sermons. Great story. I could tell it to you here but you'd just get in trouble. You'd be off to town tomorrow morning and tell your friends you talked to the *real* Saint Peter yesterday and he told you a new parable of Jesus. For that they'd probably put *you* on the water wagon.

Anyway, the storm thing was a miracle. I think we were all so glad not to be swamped and drowned that we actually didn't think much about it until we got to shore the next day. I know I didn't. It says in Mark's book that we all said, "Who is this that the wind and sea obey him?"

Nobody said that in *our* boat. We might have been thinking it, but nobody said that or anything else for a long time. We were all too busy bailing. In our boat, when we had thrown out the last bucketful and were standing up to stretch our backs, Andrew wiped the sweat and rain off his face, flicked his fingers dry, then looked at Jesus and said, "Thanks." Jesus gave him the nicest smile. Then we all laughed. You know how you can laugh after you have been terrified? We all laughed like that — except for Jesus. He just chuckled at us and shook his head.

We saw a lot of miracles in those years. I've heard people say if they had really seen some of Jesus' miracles they would have an easier time with their faith. I don't think so. Sure the miracles were exciting; sure they drew crowds and they sometimes made us whisper and hush for a while afterwards, and they certainly made Jesus more of a mystery to us, but they didn't help my faith that much.

And remember this: the miracles didn't help Judas at all. He saw most of them — but he still sold out.

What really made me believe in Jesus was not that he could heal a blind man or feed 5000 people or quiet a storm in the middle of the sea. What made me love him and work for him and die for him was that he stilled the storm in my mind and in my heart.

Do you remember reading about what I did on Holy Thursday

night, how I betrayed him? I don't even like to think about it, much less repeat what I said. It still hurts. I swore quite a bit, too, and I don't like to repeat that. Especially with all the little kids you have here. But I did it. Three straight times I did it, just like he had predicted. I swore and cussed and said I didn't know Jesus — never heard of him.

Do you know how he paid me back for that? He forgave me. That's why I believe in him, not because he could handle blindness or leprosy or storms. I believe in him because he forgave me.

That's why you should believe, too. He's also forgiven you and you should never forget it. Believe in miracles if you like, but never forget the real miracle is Jesus loves you and forgives you, just like he loved and forgave me. He can still storms in your heart; he can quiet the troubled waters in the depths of your soul. That's the real miracle.

I have to go back now. I'm looking forward to seeing all of you up there. It's not really *up* there — but it's there. I don't guard the pearly gates either. There aren't any pearly gates. Actually, there aren't any gates at all. But it's nice there. You'll like it. You'll meet lots of your friends again, and your family. We stay busy and it's fun. When your time comes, some of us will be there to meet you and help you across. There aren't any dangerous storms over on our side. Not *in* you. Not *around* you either.

I'll look for you. We could go fishing if you like.

O Savior, whose almighty word
The winds and waves submissive heard,
Who walked upon the foaming deep,
And calm amid the storm didst sleep:
O hear us when we cry to thee
For those in peril on the sea.

(William Whiting, 1825-1878)

6

Saved By Water: The Well

John 4:7-29

The legend of Noah and the flood, and Jesus' miraculous still-ing of the storm ,are both stories of fear of water and fear of drown-ing. We are indeed afraid of drowning; most of us would admit it. Too much water scares us. But go to the opposite extreme, too little water, and hardly anyone is afraid. Who ever thinks of dying of thirst? I guess you'd have to live on the desert or maybe back in the old sailing days of dead calms and thirst-crazed sailors. I don't suppose many of us have ever thought of dying of thirst.

About the nearest we can come to feeling thirst is when we watch an old Wagon Train movie on TV, or one about a posse of cowboys on the desert. Sooner or later, in those films we see John Wayne or Gary Cooper under a relentless sun, crawling on hands and knees toward a water hole — which may or may not be dry. As we watch, our mouths begin to feel chalky, our tongues swollen and parched. Just then the station cuts away and we find ourselves watching a commercial for Coke or Pepsi or 7-Up. We trot to the refrigerator and that's the end of our struggle with thirst.

It wasn't so easy in olden times. Water wasn't always easy to find. Some anthropologists think that lack of water was probably a big reason for cooperation in earliest human societies. When there was no water, people could forget their differences and band together to find some.

Jacob's well, near Sychar, at which Jesus met the Samaritan woman, was such a project. It was probably dug when Jacob lived, many hundreds of years before Christ. That well must have been some grand engineering project for those early times, nine or ten feet in diameter and 105 feet deep, as it was — and most of it dug through lime stone. Even today, visitors to Samaria say the water from Jacob's well is the best drink for miles around.

Jacob's well must have been dug during a long dry spell. There are normally both streams and springs in those hills, and the water in the well is usually only seventy-five feet down. It must have been unusually dry when the well was dug. When there is no water, people will work hard to be sure they can get some. People don't like to risk low water, or no water.

Mohandas Ghandi, India's great champion, proved to the whole world a person can go without food for a long, long time — for weeks — but water is something else. I don't know how long someone can live without water, but it isn't very long. A baby who can't keep down fluids will dehydrate and die in just a few days. Adults last only slightly longer. The only life-sustaining substance that we need more frequently than water is air.

Water, then, is essential to life. In one sense, water *is* life. Where there is no water, there is no life. Cactuses and camels and gnarled trees and grasses of the desert can adapt to conditions of low water, but there isn't any living thing on this earth that can adapt to *no* water. "Water is life." Lack of water is death. To be thirsty is to stare death in the eye.

It's no wonder that Jesus turned water and thirst into spiritual teachings as he sat there by Jacob's well, that ancient and sacred place for quenching thirst. If thirst of the body is the very taste of death, then thirst of the soul is the very picture of spiritual despair.

That was the kind of world Jesus came to save, a world dying of spiritual thirst, a world of dry spirits, of dry souls, a world of inner deserts, of swollen tongues and cracked lips and parched throats; a world of inner springs of the soul run dry.

To be spiritually dry, to be in the soul's desert, is to experience real despair. The soul without Christ, the spirit without living water, is in such a dry place. He thirsts, he dies, but doesn't know where the water is.

The strange truth about spiritual dryness is that it is altogether like some of the ironic Hollywood desert tragedies. As the Hollywood tragic hero collapses and dies on one side of a sand dune, the camera rises and seems to look over the other side of that dune. There is an oasis; there is water; there is life. Death is on one side, life on the other. The hero dies just a few paces away from life.

The person whose soul has dried up is usually only a little way from water, too. His tragedy is that something hides the water from him; something keeps him from seeing and drinking the waters of

life. It is usually some pet or favorite sin.

Jesus had a way of getting right at that kind of problem. To strike up a conversation with Jesus, as the Samaritan woman did at the well, was to take a risk. Jesus never was one to make chit-chat and small talk for very long. Sure, he might simply ask for a drink at first, but a conversation with him almost always got serious. By the second minute of their conversation, Jesus was deeply involved in the Samaritan woman's life. He had a message for her, a truth for her. He had a tall glass of spiritual water for her killing thirst. To get her to drink it, he had to get to the problem, to get her over that last desert sand dune. .

Jesus often used this kind of Law-Gospel approach. Today we might call it the "bad news-good news" approach, reminiscent of those jokes we hear from time to time. If we read on in this story, we learn quickly what the woman's bad news was. For the woman at the well of Sychar, the bad news was her messed up sex life.

"Go call your husband," Jesus said. Before too many more words were spoken, *she* knew that *he* knew she was now sleeping with her sixth man, and they weren't even married. "Go call your husband," indeed! She was shaken to the core. "I wonder what else he knows," she thought. Maybe her throat began to feel a bit dry. "I guess you must be a prophet," she said. All of a sudden she wanted to talk about *him*. The conversation had gotten too close to the dry spot in her life.

The same thing happens when you and I strike up a conversation with Jesus. That conversation will very soon come to focus on *our* dry spot. Jesus has a way of cutting through the small talk and getting right into our desert places. To the rich young ruler, proud, arrogant, secure in his morality and his wealth, he said: "Go and sell all you have and give it to the poor." To Zacchaeus, one of the short people, a man who may have hated himself almost as much as the people he taxed hated *him,* spiritually as well as physically "up a tree," Jesus said, "Come down. We're going to your house for dinner." To Peter, in a moment of pride, Jesus said, "Get behind me Satan," but in a different kind of moment, a moment of Peter's penitence, Jesus asked, "Do you love me?"

Jesus could slice right through the small talk. To the woman at the well he said, "You are right in saying you have no husband; you have had *five* husbands and the man you now live with is sure enough

not your husband." Whammo. Bullseye. He hit her right between the sand dunes in her spiritual desert.

She tried to change the subject. She tried to talk about *him,* about his religious insights and then about worship and where the temple ought to be built. "Let's get into a religious discussion," she was saying. "Let's talk about religious ideas. Let's get out of my desert and into a no-risk discussion topic."

Then Jesus said some things about worship. The significant words for her were probably not those we think are important: the business about worshiping in spirit and in truth. She wasn't ready for that. No doubt the significant words for her were: "The time is now coming." Jesus repeated it twice: "The time is coming, *and now is. . .*" He made that woman — that ordinary, everyday, weak and sinful woman — he made her aware she was dying of thirst, just inches from the living water. She stood face to face with the one man who had life to give, who was a very wellspring of eternal water.

"The time is coming and now is. . ." he said to her. This is it. You are there. The waters are beginning to flow, living waters, eternal waters. "I who speak to you am he," Jesus said. "I'm it."

When she began to suspect he really *was* it, she also realized she had been living in her sexual desert long enough. It was time someone gave her water. She was not a leper; she was not blind, deaf, or lame; but she had been crippled, disabled, and dried up by her inability to develop a constant love for herself or for any of the men in her life. With glaring bluntness, Jesus had shown her the desert places in which she had lived. He revealed to her her desperate thirst. Then he gave her a drink. "I who speak to you am he," he said. I am the Messiah. I'm the one of whom the prophets spoke, for whom the people prayed, by whom the sins of the world will be forgiven. I am the living water. "I who speak to you am he."

That woman took a long drink. She very nearly leaped out of her desert right then and there. She was so excited by the possibility that she dropped her water jug and ran off toward the city to tell everyone about the prophet.

Her footrace into town and her shouted message might well be one of the funniest scenes in the whole Bible. Imagine how excited she was, how thrilled. She was just bubbling over. She ran into town — and that, in itself, may have raised eyebrows. "What would make that woman run?" they wondered. She was too cool to run. High speed for her was probably just a notch above "slink."

She didn't just run, she shouted about a prophet out by the well. "Come and see a man who told me *everything I have ever done,*" she shouted, which is to say, "Come and see a man who can read minds."

Remember now, this was the woman who had gone through five bad partners and was now sleeping with a sixth. This was the scarlet woman of Sychar. Now I ask you, would you have gone out and listened to a prophet who knew all and might *tell all* about that woman? No question! Call it first century soap opera if you like.

There was another part of her message. It was a question. "Can this be the Christ?" she asked. That was her whole evangelism, her whole pitch. She simply told what she had seen and heard of Jesus and then she asked that simple question: "Can this be the Christ?"

You and I don't need to ask that question; we have the answer. He is the Christ. He is the coming one arrived. He is the living water for any sort of spiritual dryness, for any spiritual desert on which any of us might walk.

The woman of Sychar was on a sexual desert. A lot of people are. There are other deserts. Many of us have at least one foot in some kind of desert; it may be a desert of greed or selfishness or spiritual pride or fear or hatred or anger or an unforgiving spirit. Whatever our desert is, it is drying out our spiritual selves; it is killing us. We are dying of thirst.

To that desert — our desert — comes the same living water that came to the woman at the well. For every kind of spiritual dryness, for every spiritual desert in which any of us walks, there is water, spiritual water. Jesus himself is that water. He promises that water to any of us who will have it. Listen to that promise; hear his words:

"If any one thirst, let him come to me and drink. He who believes in me, as the scripture has said, 'out of his heart shall flow rivers of living water'."

(John 7:37, 38)

Instead of a desert, there are rivers of living water. Why *would* anyone, why *should* anyone, die of thirst?

I heard the voice of Jesus say,
"Behold, I freely give
The living water, thirsty one;
Stoop down and drink and live."

I came to Jesus, and I drank
Of that life-giving stream;
My thirst was quenched, my soul revived,
And now I live in him.

(Horatius Bonar 1808-1889)

7

Serving With Water: The Washing

John 13:3-15

You have heard it said, "Clothes make the man." Or perhaps it was put this way: "You are what you wear." We may laugh off these old truisms but you and I are more deeply influenced by clothing than we think. Flashy, expensive clothes impress us. So do uniforms. So do specialized occupational and professional clothes.

Why do we quickly reduce our driving speed when we see a uniformed patrolman or immediately feel guilty when a policeman comes to our door? Why will a crowd of otherwise profane men quit swearing when a priest or pastor wearing a backward collar shows up? Why do judges continue to wear robes — and, in England, even wigs? Why are we more apt to believe vitamin ads on TV if the person holding the pills wears a white doctor's coat?

Clothing has an effect on us.

These effects are often achieved because clothing can classify people according to occupation. People *do* what they wear. In the largest and broadest way, we divide occupations into two groups — the "white collar" and the "blue collar." Even the rather negative term "red-neck" must originally have had something to do with where one worked and what he wore. White collar workers don't get red necks under banks of eight-foot fluorescent tubes. They don't get farmers' tans either.

These divisions and distinctions have an impact on us. We often react to people because of what they wear and what they drive and how they live. We make judgments about them on that basis. As often as not we're wrong, but we do it anyway.

I remember driving a half-dozen of my young hockey players home one day after a practice session. As we dropped one boy off, another looked at his suburban house with its attendant boat and camper in the driveway and said to him, "You must be rich." We

all laughed.

As we drove on and dropped off the other boys one by one, the conversation remained centered on which kids on the team were "richest," as far as that could be judged by appearances. Houses, cars, clothing, even hockey equipment was entered into evidence. Everything depended on the "appearance" of affluence.

Finally, when only one boy and I remained in the car, I spotted a man I knew on the street. "See that man?" I said to Paul. "Yeah, that one; the one in jeans and boots and with the hybrid seed corn hat." Paul could see him, but he obviously wasn't impressed. "He and his two brothers," I went on, "own four sections of land west of town. That's over 2500 acres. At today's prices that land is worth about four million dollars." There was a long pause. Then Paul said, "He sure doesn't spend much of it on clothes."

Appearances make an impression and clothing is a big part of that impression. People do dress in certain ways for certain jobs. What they wear and how other people react to what they wear become signals.

Jesus gave his disciples and all of us a gigantic signal when he took that basin of water and began to wash feet. On Holy Thursday, that special Thursday, that mysterious and memorable night when Jesus and his disciples ate their last meal together, Jesus acted out what he had been teaching them for three years. He acted out what it meant to be a servant. He did it with clothing and with water.

Over those years, Jesus had said things about serving, in a dozen different ways and in a dozen different places. Often his teachings about servanthood and humility were prompted by the proud bickering of the disciples,—,arguments about who was the greatest among them and who would have the most honored place in the kingdom of heaven.

When they began bickering in these ways, Jesus was apt to say such things as:

> *"Whoever would be great among you must be your servant, and whoever would be first among you must be your slave."*
> *(Matthew 20:26)*

Or:

> *If any one would be first, he must be last of all and servant of all.*
> *(Mark 9:33)*

Or, he might tell them the parable of the seating arrangements at the banquet, or the parable of the Pharisee and the tax collector.

Again and again, Jesus taught them lessons of humility and service. But what did they do after they ate that beautiful, meaningful, and mystical Last Supper? They began once again to argue and bicker about who was going to be the greatest. (Luke 22:24-27)

By that time there was no time left. On the last night of his life, it was too late for words. Jesus began to act out a lesson in humility. He began with clothing. He took off his cloak and robe, the uniform in which he had spent three years teaching, the clothing of his preaching and healing. He stripped off that uniform of his lordship and laid it aside. He stood there before them naked, stripped to the waist, with no uniform at all.

Then he changed into the uniform of the lowest household slave. He wrapped himself in a towel. His clothing became their bathmat. He wore — he actually *became* — that on which they would wipe their feet. Jesus, the Son of God, dressed himself as the lowest front-door, foot-washing slave. He acted out his own lesson. He became the least of all and the slave of all.

Nor was this a masquerade. Jesus didn't just slip into the towel and say, "See, see. I'm not afraid to dress like a slave." He wasn't acting a part, like one of those fashion-plate hippies who wear $125 decorator jeans with artistically arranged patches, with just the right shade of bleach, and exactly the most attractive amount of fray on the cuffs.

The role of slave and servant wasn't a short-term game Jesus played only on Holy Thursday. Slavery was for him a lifetime role. He had been playing that role from the beginning and he stayed in it all the way to the cross. Jesus was born a king, but a king who walked through his kingdom on foot as a suffering servant, just as the prophet Isaiah had predicted. Not only did Jesus *dress* like a slave, he *acted* like a slave and *served* like a slave. He took a basin of water and began to wash their feet.

As Jesus went from disciple to disciple, it was almost as if he was baptizing their feet. Some of the disciples merely submitted. They didn't fully understand, but they let Jesus go ahead anyway. He washed their feet, which he then wiped on his towel, on himself.

But not with Peter. For once, Peter knew exactly what was happening and he wanted no part of it. Peter knew who Jesus was. But fully as important, Peter knew who he himself was.

This Peter was the fisherman who once had tried walking on water. It only partly worked, but Peter knew how special it was even

to have tried. When he had gotten back safely into the boat, he had said to Jesus, "Truly you are the Son of God." (Matthew 14:33)

This same Peter was the one who had responded to Jesus' question, "Who do you say that I am?" by answering, "You are the Christ, the son of the living God." (Matthew 16:16)

This is the same Peter who said of himself to Jesus, "Depart from me, O Lord, for I am a sinful man" (Luke 5:8), and of whom Jesus had said, "You are Peter, the rock on which I will build my church." (Matthew 16:18) And, on another occasion, Jesus had said to Peter, "Get behind me, Satan. You are a hindrance to me." (Matthew 16:23)

Peter had all these mixed feelings about himself and his own place in the kingdom. His image of himself was confused. But when he compared himself to Jesus, he had no mixed feelings at all. He knew who was the sinner and the slave — and who was God and Lord and King.

When Peter saw Jesus wrapped in a towel and washing feet, he was disturbed. It bothered him to see the roles reversed. His feelings were like those of John the Baptist at the Jordan: "You should baptize *me,*" John had said. "I should *wash* your feet," Peter was saying. "*You?* Wash *mine?* Never!"

That was Peter's system. He figured things out in his own way and then acted on those conclusions. He had protested loudly when Jesus predicted his own death and sacrifice. He had pulled a sword in the Garden when Jesus was ready to surrender peacefully. And now, on the most solemn and personal evening of their several years together, on this special night when Jesus took bread and said, "This is my body," and when Jesus took wine and said, "This is my blood," and when Jesus took water and said, "This is my ministry," Simon Peter said, "No."

Peter didn't take long to convince. Jesus quickly said to Peter (maybe mostly with his eyes), "I want to wash you into my ministry, I want to wrap you in my towel of service. I want to share my serving and my servanthood with you."

Peter quickly got the idea and, suddenly, he wanted more: "If a footwashing will make me more like you, then wash me all over. Scrub your ministry, your service, your love into my whole body."

"No," Jesus said, "just your feet. Then you're clean all over."

Peter was given a lesson in symbol and in sacrament. If a little washing was good, Peter was saying, then why not a lot.? Because

symbol and sacrament don't work that way, Jesus said; because the washing didn't come from the basin, but rather from the heart and to the heart. The water was just a symbol, a sacred sign.

On that night of nights, Jesus said to the disciples (directing it, of course, to Judas), "Not all of you are clean." Jesus could and did wash Judas' feet; he could have scrubbed Judas all over. But Jesus knew — and you and I know — that you can't scrub the heart by washing the feet, or even the whole body.

The heart of man, the fallen and corrupt hearts of all the sons of Adam and the daughters of Eve, can only be scrubbed clean by faith and by words and by the declaration of God. The small ritual washing of feet on Holy Thursday only represented what had happened and what would continue to happen to those followers who remained faithful. There was no coming back for Judas; there would be no turning back for Peter and the others, once Jesus had washed them into slavery and service to his cause.

The same is true of those few drops of water that once washed you and me into this great enterprise. And it's true of those tiny sips of wine and those tiny wisps of bread: they remind us again and again that, as Jesus served, we must serve; as he was obedient unto death, we ought at least be obedient in life.

Thus these tiny symbols remind us again and again of truths much larger: a taste of Christ's body fills us with his body; a sip of his blood fills us with his blood, his life; and the splash of water that once drowned our sin can remind us that we are indeed — and continue to be — washed clean all the way through by the servant, the slave who was this world's king and God, our Lord, our Savior, our friend — Jesus the Christ.

Nothing in my hand I bring;
Simply to thy cross I cling.
Naked, come to thee for dress;
Helpless, look to thee for grace;
Foul, I to the fountain fly;
Wash me, Savior, or I die.

(Augustus Montague Toplady, 1740-1778)